# OUTERNET

Dário Cannatà

# OUTER NET

# OUTERNET

OUT R NET

OTRNT

OUT
HER
NET

OU
TER
NET

Hello citizens.
I apologise for addressing
you in a secretive manner.

I do not mean to scare you.

大
大
大
大
大

I must protect myself.

LOADING

LOADING

I bring a message of opportunities
and possibilities. A message of process.

Under the name *Outernet**, I propose
a conceptual framework to provide
the limits to discuss structural, and mostly
positive changes that may arise from
our contemporary context.

\* Not to be confused with Outernet (www.outernet.is),
an ambitious project currently under development
to provide wireless internet access anywhere in the
world through the use of satellites, overriding the
need for land or sea infra-structure.

The level of communication that
we have reached as a society has not
been matched by our physical world.

We can talk and share information
freely, or easily at least, around
the world but we still face borders
when crossing countries and
different laws that allow exploitation
by international corporations.

With the advent of the internet,
connections
between people and things
became denser, more specific
and took on a local component:
depending on our interests
and needs, different information
is available, even if invisible,
in the environment.

Relations however,
between people and things,
become the opposite.

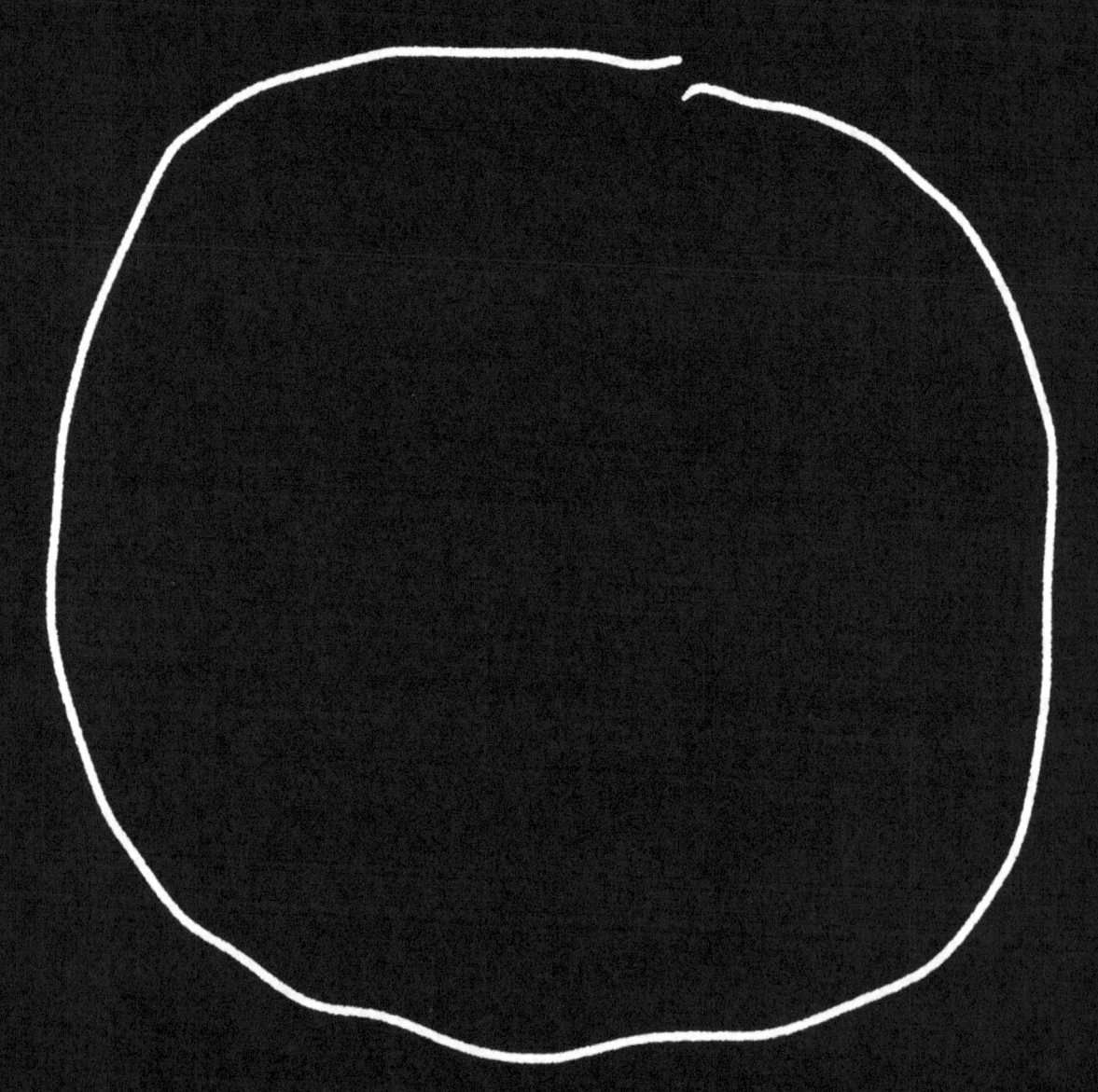

A new dimension of perception
is created in which virtuality and reality
are merged into a different paradigm.

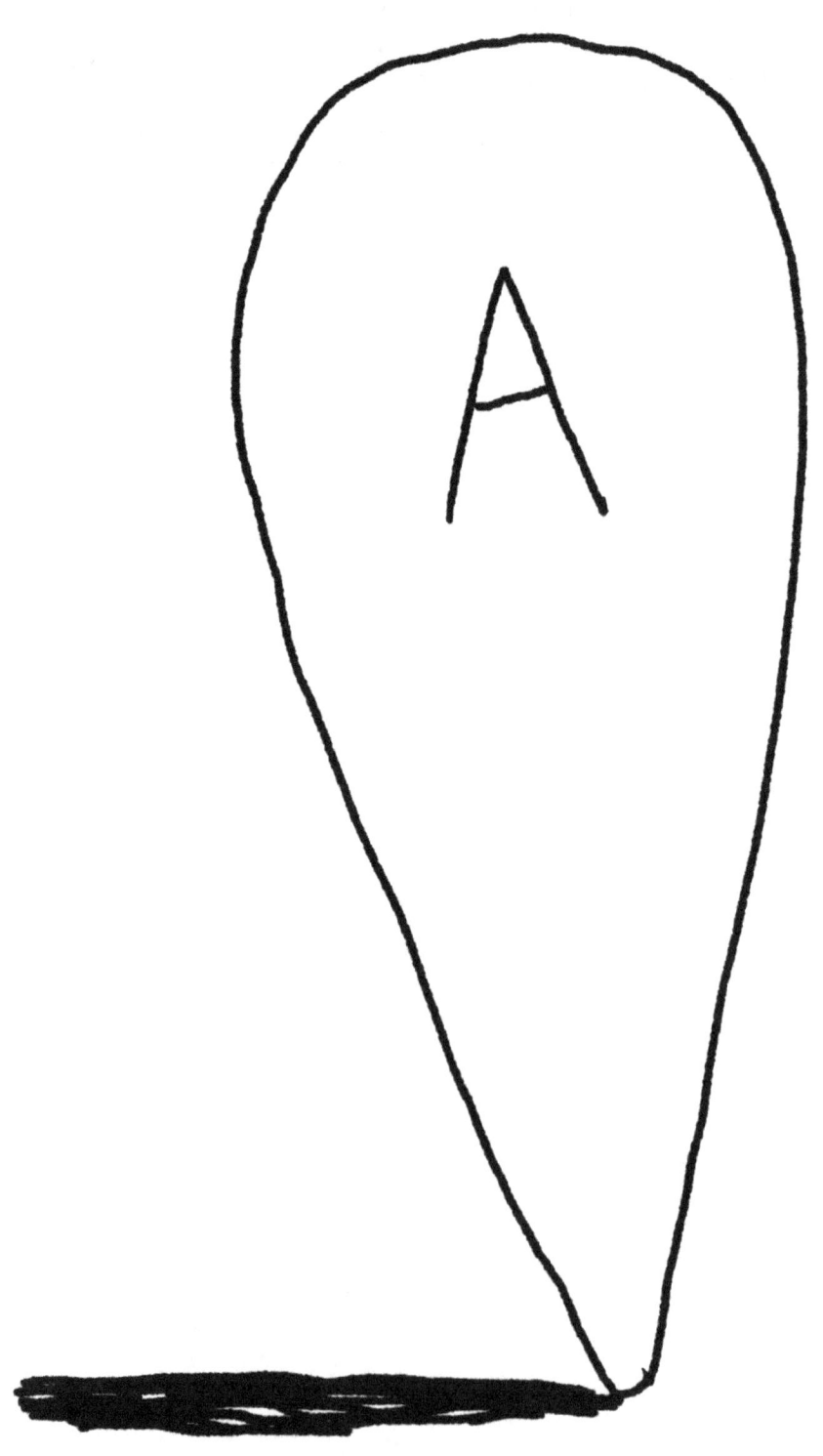

When the European Union launches the Galileo satellite navigation system there will be a significant improvement in localization accuracy: in the freely available service people and objects can be localized to an accuracy of about 1 meter, and paying customers to the centimetre.

Radio-Frequency Identification (RFID) tags are tiny radio modules which permit the automatic remote identification of objects.
They are already quite common in public transportation tickets or ski passes and electronic labels, used to link objects to any information.

Sensors act as the sense organs of objects.

Brightness, noises, temperature
or pressure – they make it possible
to read out the surrounding situation
sensitively on different levels.
On the basis of this information,
mobile devices can interpret the context
in which a person is currently to be found.

Video and sound recognition technology allow machines a greater perception of our world and a better communication with human beings. Live motion capture, face, gesture and speech recognition dictate that the Internet is leaving the previously detached realm of cyberspace and soon it will conquer the streets.

# The Internet will explode into the real world

However, there must be greater
consequences then simply
commercial exploits trying
to advance for the sake of money.
Live publicity, intelligent
cell-phones and self driving
cars are simple tools for human life.

The greater consequences will
come from a change of perspective.
This technologies bring with them
fresh theoretical paradigms,
that question the main foundations
of human societies.

A conscious perception
of our globalized world allows
a greater reaction for the
downsides of the human
condition embracing a continuous
sense of time, and space.

# We know things we previously couldn't know

We are
more erratic
and
more enduring

We can achieve a new social contract according to the conditions of an open public world, one that can not be govern by corporations. A world that all may enter without privilege or prejudice accorded by race, economic power, military force, or station of birth.

All over the world, governments are trying to ward off the virus of liberty by erecting guard posts at the frontiers of Cyberspace. These may keep out the contagion for a small time, but they will not work in a world that will soon be blanketed in bit-bearing media.

Consider the Outernet as platform for chaos and a bringer of disruption.

# LULU

**Outernet**

Dário Cannatà — March 2015, Porto

    Text remixed from:
    – John Perry Barlow, *Declaration of the Independence of Cyberspace*, 1996
    – Proximity WORLDWIDE/TrendONE, White Paper: *The Outernet*, 2010

    Cover image: Google Earth wrapped in beach ball
    Cover font: Naimara
    Main text font: Times New Roman
    This font: Info Text

On occasion of the colective exhibiton *y [why?]*
at Paços do Concelho, CMP — Praça General Humberto Delgado, Porto, Portugal
on display from 19 of March to 25 of June 2015

curated by
Drumond Frutuoso

co-produced by
Pelouro da Cultura (Câmara Municipal do Porto) + Saco Azul, A.C. + Drumond Frutuoso

with the following participants:
AND ATELIER
ATLAS PROJECTOS
BRUNO ZHU
DIANA CARVALHO
JÉRÉMY PAJEANC
JOÃO SOBRAL
MÁRCIA NOVAIS
MARIA TRABULO
PEDRO HENRIQUES
SVAR
WETHEKNOT

    Ⓒ 2015 Dário Cannatà. Some rights reserved.
    ISBN: 978-1-326-20923-0

    Published through lulu.com